RHODE ISLAND

WRITTEN & ILLUSTRATED BY TOM GASTEL

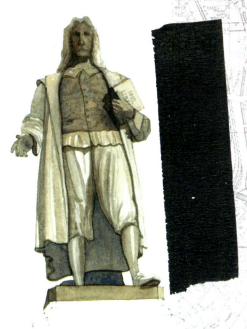

ROGER WILLIAMS SCULPTURE
ROGER WILLIAMS PARK

During the winter of 1636 Roger Williams fled the Massachusetts Bay Colony for his own safety. He settled on land next to the Mooshassuc River, and after other persecuted individuals joined him, he called the settlement "Providence." Roger Williams is known for his beliefs in the separation of church and state, establishing the first Baptist church in America, and his fair dealings with Native Americans.

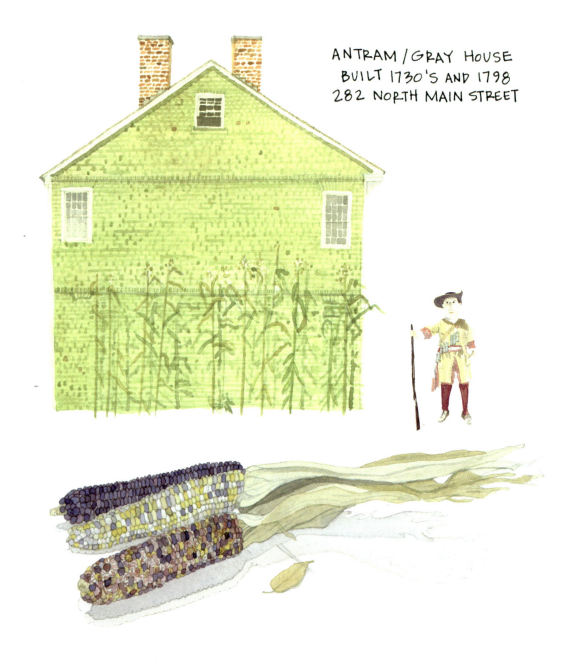

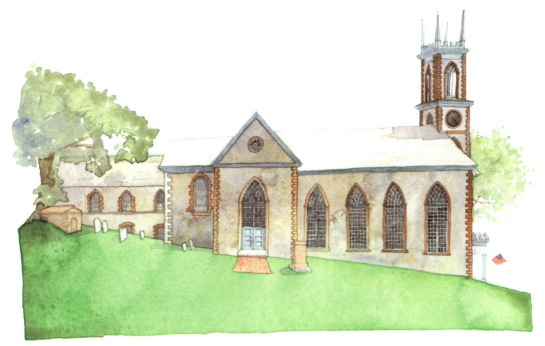

CATHEDRAL OF SAINT JOHN
BUILT 1805
271 NORTH MAIN STREET

Originally named "King's Church," the congregation of the Cathedral of Saint John was founded in 1722. The original building of the cathedral was designed by local architect John Holden Greene.

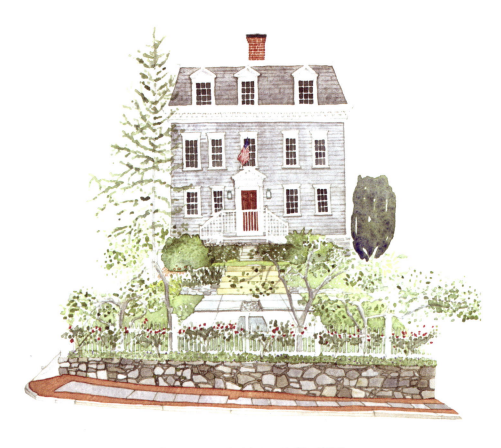

BENJAMIN ALLEN HOUSE
BUILT 1787
9 CHURCH STREET

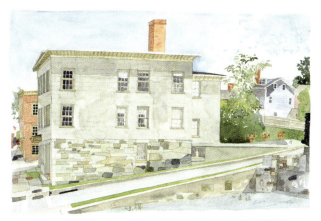

SITE OF ORIGINAL ROGER WILLIAMS HOUSE
235-237 NORTH MAIN STREET

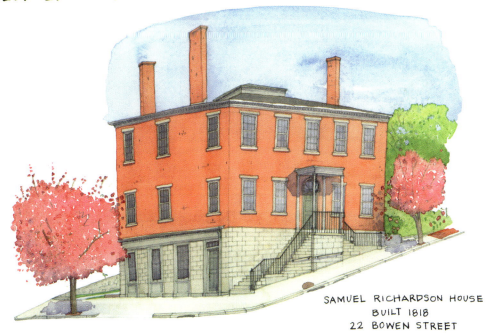

SAMUEL RICHARDSON HOUSE
BUILT 1818
22 BOWEN STREET

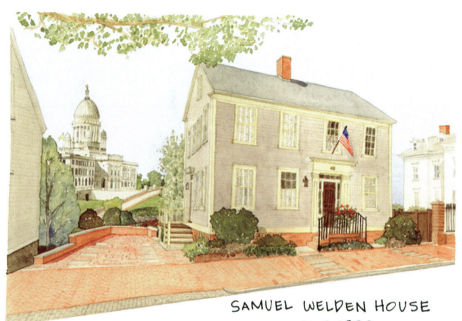

SAMUEL WELDEN HOUSE
BUILT 1830
40 BENEFIT STREET

JAMES BURR HOUSE
BUILT 1786
98 BENEFIT STREET

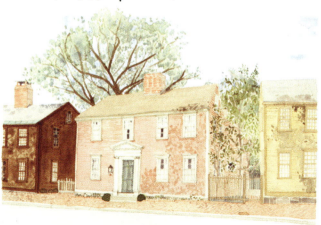

SULLIVAN DORR HOUSE
BUILT 1809
109 BENEFIT STREET

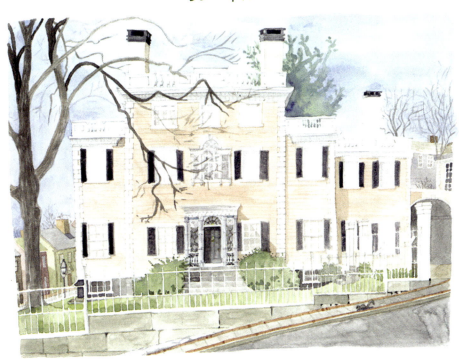

MEETING STREET STEPS

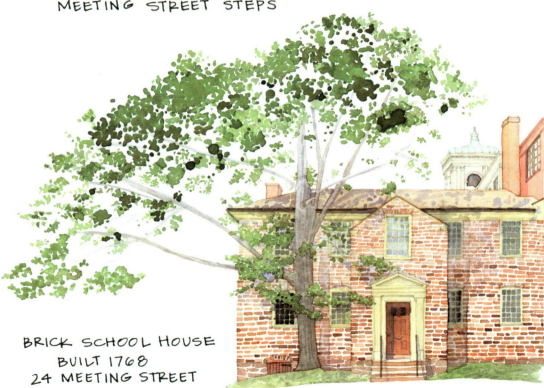

BRICK SCHOOL HOUSE
BUILT 1768
24 MEETING STREET

"Shakespeare's Head" was built by publisher and editor John Carter. Carter learned printing from Benjamin Franklin in Philadelphia. "Shakespeare's Head" was named for the carved bust of William Shakespeare on a post in front of the building.

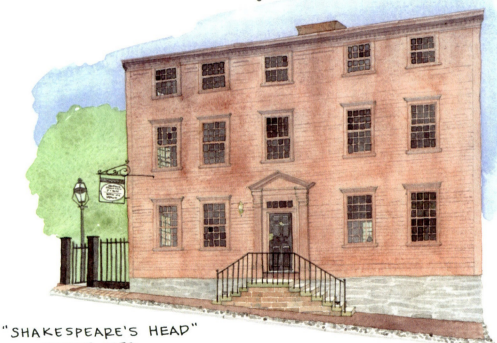

"SHAKESPEARE'S HEAD"
BUILT 1772
21 MEETING STREET

SERIL DODGE HOUSE I & II
BUILT 1786-89, 1791 RESPECTIVELY
11 & 10 THOMAS STREET

RUFUS WATERMAN HOUSE
BUILT 1863
188 BENEFIT STREET

The Seril Dodge House was originally a 2½-story Federal-style house. In 1906 the Colonial Revival first floor was added. Seril Dodge lived in the house until he built the brick Federal style house next door. In the early 1800's Dodge rented the house to his nephew who is credited as the founder of the costume jewelry industry. In 1887, the Providence Art Club moved into the building.

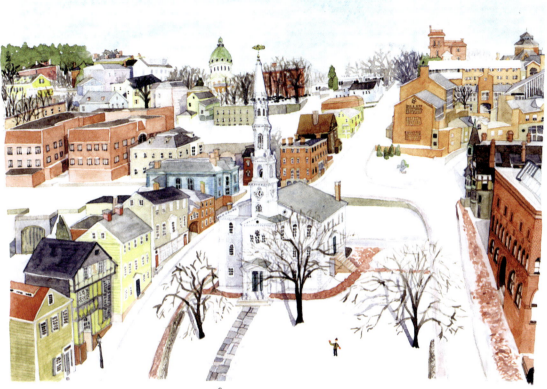

FIRST BAPTIST CHURCH
AND
COLLEGE HILL
BUILT 1775
75 NORTH MAIN STREET

I never can be tied to raw new things,
For I first saw the light in an old town,
Where from my window huddled roofs sloped down
To a quaint harbour rich with visionings.

Streets with carved doorways where the sunset beams
Flooded old fanlights and small window-panes,
And Georgian steeples topped with gilded vanes —
These are the sights that shaped my childhood dreams.

Howard Lovecraft

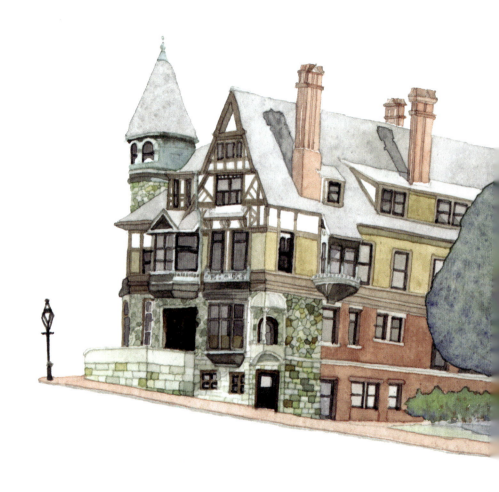

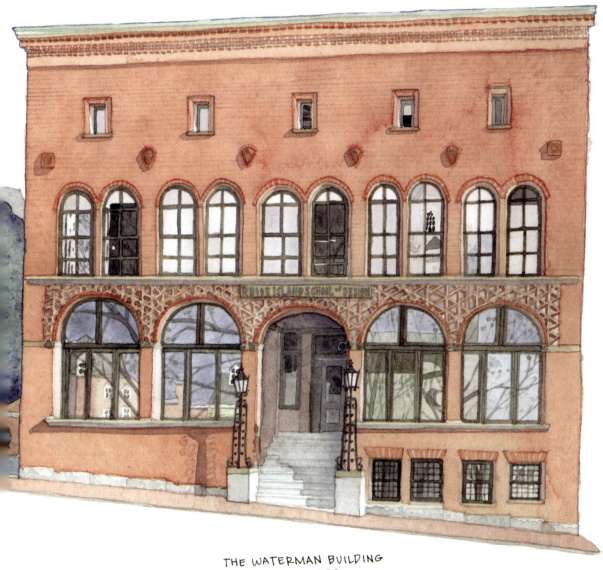

THE WATERMAN BUILDING
BUILT 1893
11 WATERMAN STREET

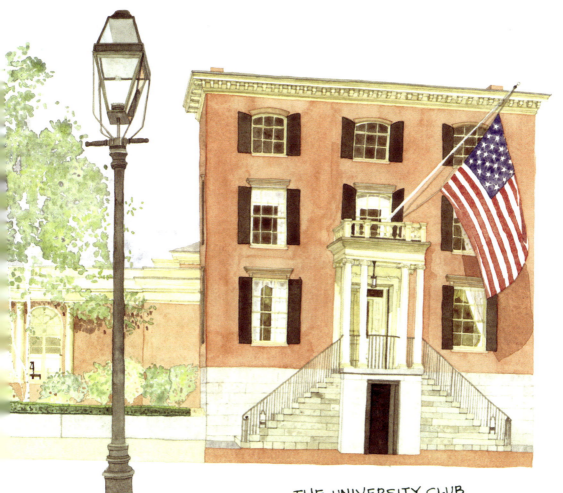

THE UNIVERSITY CLUB
RUFUS WATERMAN HOUSE
BUILT 1863
188 BENEFIT STREET

THE HANDICRAFT CLUB
BUILT 1825
42 COLLEGE STREET

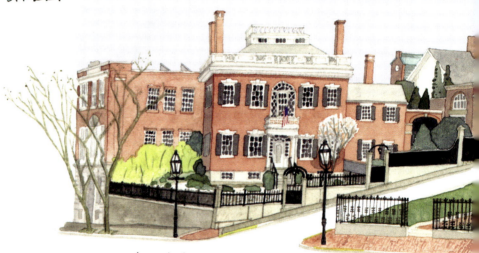

The Handicraft Club was designed by John Holden Greene and built by Truman Beckwith.

The Providence Athenaeum was designed by William Strickland, a leading designer of Greek Revival architecture in the United States. The Providence Athenaeum was established in 1831 in rooms within the Arcade (65 Westminster Street) and merged with the Providence Library Company in 1836.

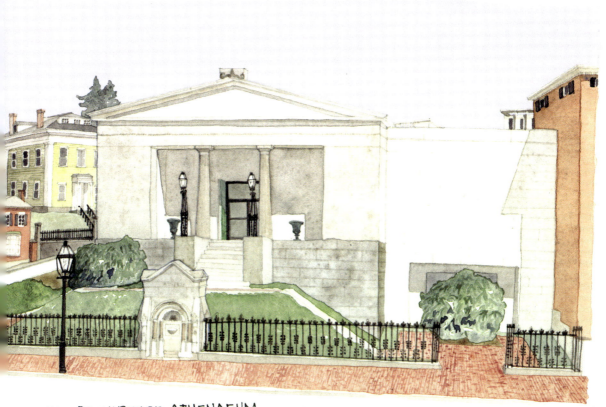

THE PROVIDENCE ATHENAEUM
BUILT 1838
251 BENEFIT STREET

When I was a student at the Rhode Island School of Design, I heard a superstition. The superstition is that if you drink from the fountain in front of the Providence Athenaeum you will one day return to live in Providence. Eleven years after moving away... I returned.

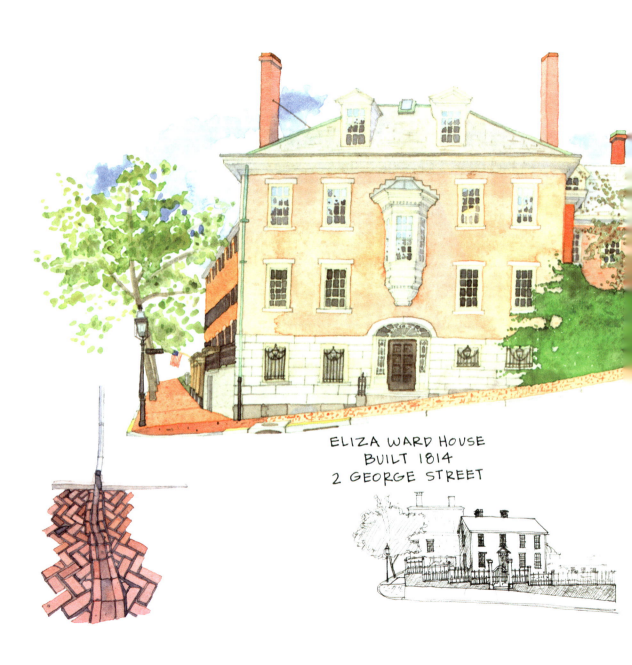

ELIZA WARD HOUSE
BUILT 1814
2 GEORGE STREET

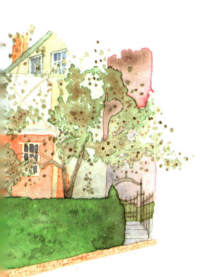
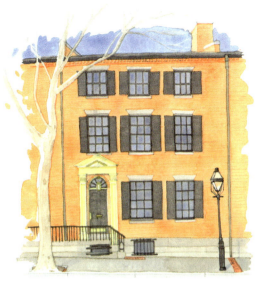

OLD BENEFIT STREET BLOCK
BUILT 1814-1819
270-276 BENEFIT STREET

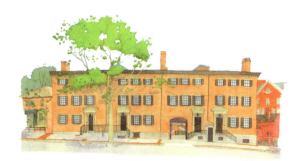
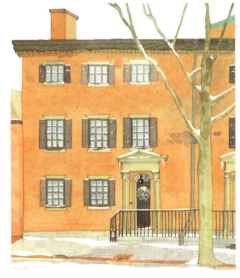

The First Unitarian Church was designed by John Holden Greene and has a blend of classical, gothic, and baroque architectural elements. The church is made of ashlar laid white stone from Johnston and wood. The steeple contains the largest bell cast by Paul Revere and son.

FIRST UNITARIAN CHURCH
BUILT 1816
1 BENEVOLENT STREET

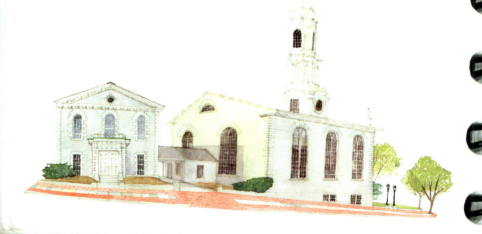

General Burnside was a Civil War general leading 24,000 Rhode Islanders during the war. Not known for his leadership abilities, he resigned from service in 1865. He went on to serve three one-year terms as Governor of Rhode Island from 1866 to 1869 and two six-year terms in the United States Senate in 1870 and 1876. He was known for his facial hair, and his name was transformed into the word "sideburn."

The General Burnside House is in the Italianate Style, known for its tall proportions, ornamental brackets, asymmetrical facades, wide overhanging eaves, side bay windows, tall narrow multi-paned windows with hooded mouldings, and segmented doors.

"The discoloration of the ages had been great. Minute fungi overspread the whole exterior, hanging in a fine tangled web-work from the eaves... No portion of the masonry had fallen; and there appeared to be a wild inconsistency between its still perfect adaptation of parts, and the crumbling condition of the individual stones."

— Edgar Allan Poe

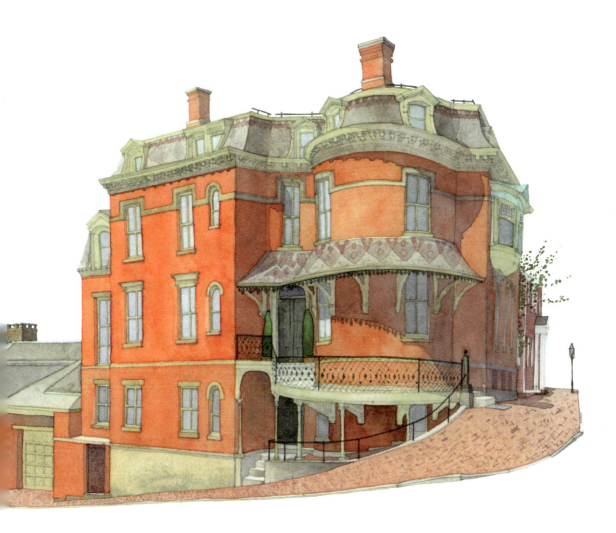

GENERAL AMBROSE BURNSIDE HOUSE
BUILT 1866
314 BENEFIT STREET

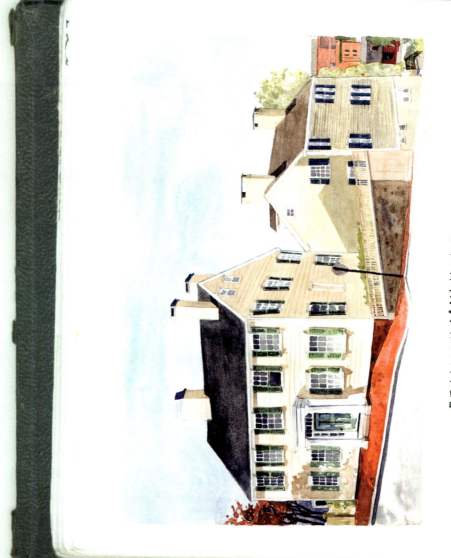

BENJAMIN MAN HOUSE
BUILT 1770
322 BENEFIT STREET

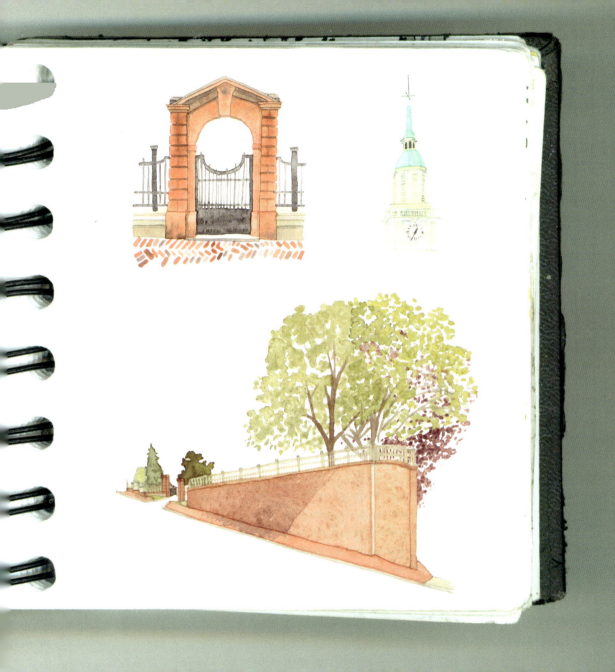

John Quincy Adams referred to John Brown's house as "The most magnificent and elegant private mansion that I have ever seen on this continent."

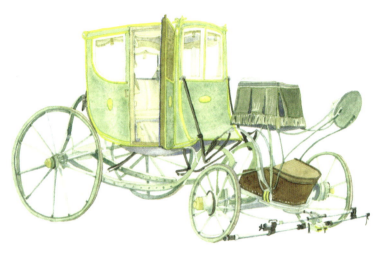

CHARIOT OF JOHN BROWN
BUILT 1782

The Chariot of John Brown was built in 1782 in Philadelphia. Typically the chariot was driven by 1 or 2, but sometimes 4, horses. Under the bench for the driver is a storage bin for hay, and at the rear is a platform to carry luggage.

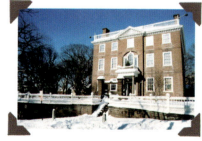

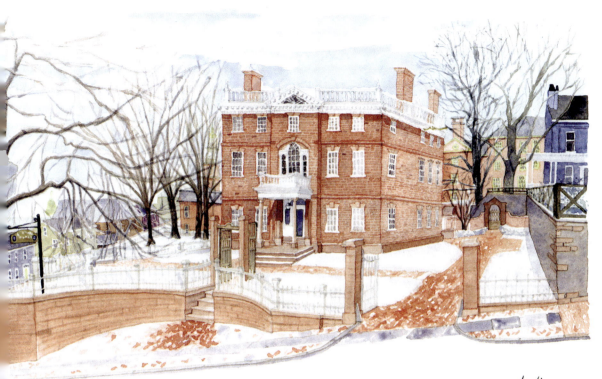

JOHN BROWN HOUSE
BUILT 1788
52 POWER STREET

John Brown was a prominent figure in Providence in the 18th century. His income was primarily based on trade with China and, to a lesser extent, the slave trade. The house was the first Georgian style home in Providence and was designed by John's brother Joseph. The brick was brought over from England.

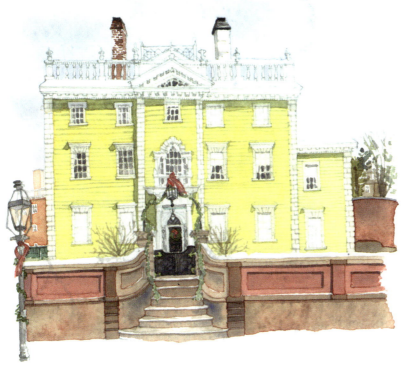
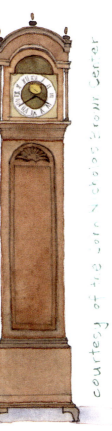

NIGHTINGALE - BROWN HOUSE
BUILT 1792
357 BENEFIT STREET

girandole mirror, early 19th C,
American or English, Federal style,
used primarily as a lighting device

grandfather clock, +/- 1775,
made in Newport by Thomas
Claggett

courtesy of the John Nicholas Brown Center

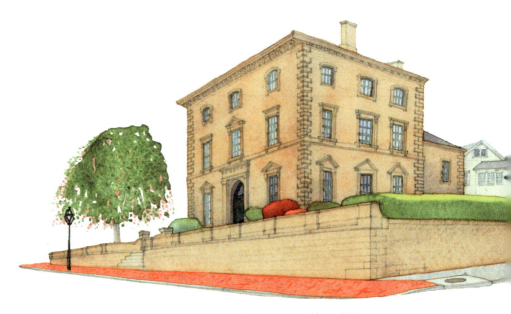

TULLY BOWEN HOUSE
BUILT 1853
389 BENEFIT STREET

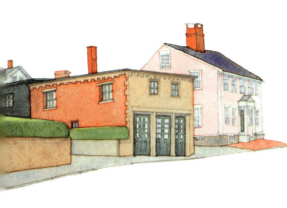

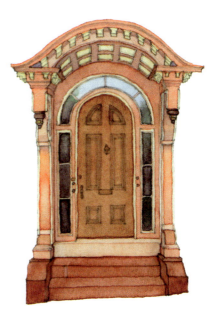

BENJAMIN CLIFFORD HOUSE
BUILT 1805
392 BENEFIT STREET

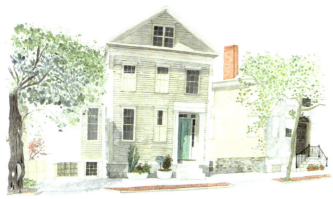

JENKINS D. JONES HOUSE
BUILT 1846
418 BENEFIT STREET

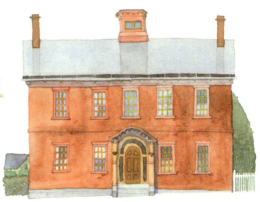

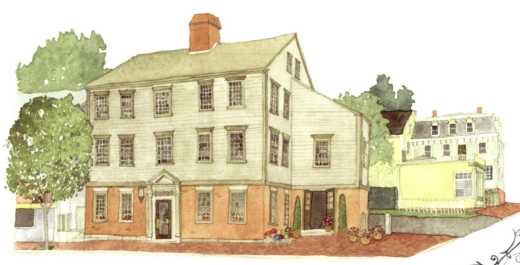

SIMEON INGRAHAM HOUSE
BUILT 1835
174 WICKENDEN STREET

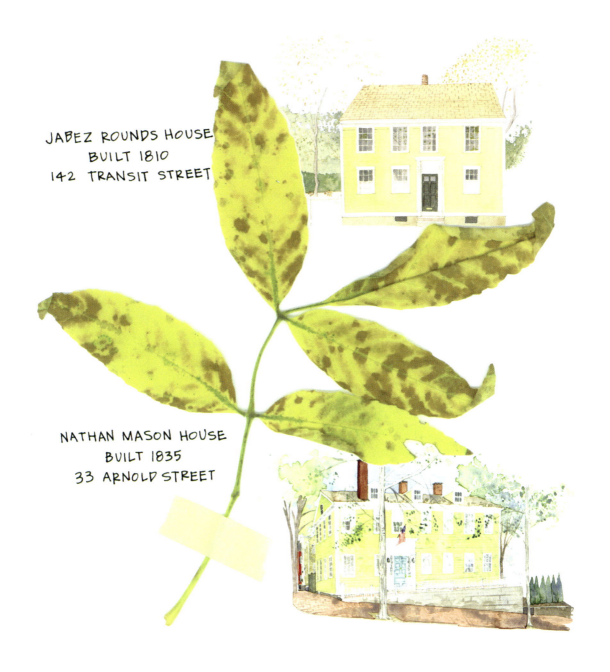

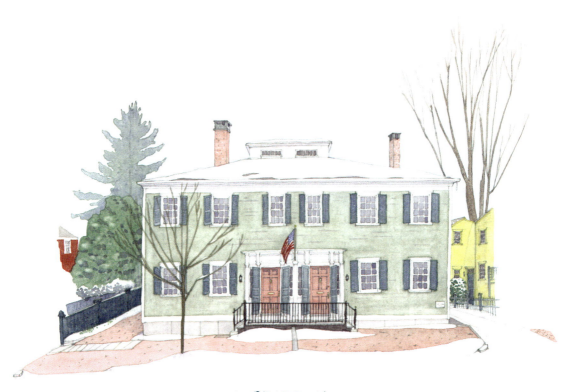

LEVI PEARCE HOUSE
BUILT 1823
27 JOHN STREET

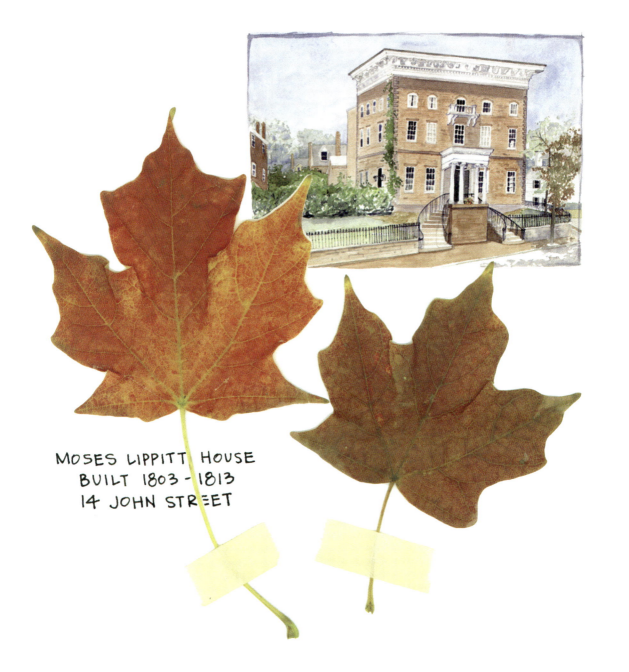

GATE AT THE CARRINGTON HOUSE
BUILT 1810 - 1812
66 WILLIAMS STREET

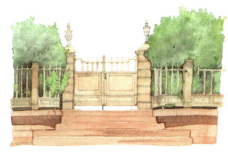

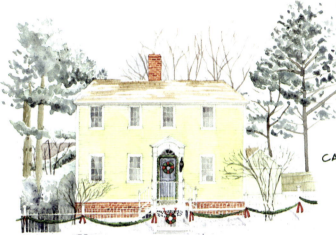

HOUSE BUILT BY
CALEB - EARLE & SANFORD BRANCH
BUILT 1808
81 POWER STREET

THE CARRIAGE HOUSE AT THE
EDWARD CARRINGTON HOUSE
BUILT 1810 - 1812
69 POWER STREET

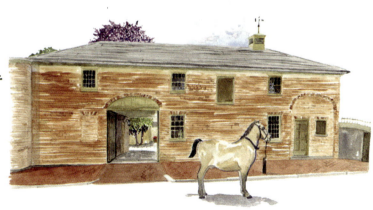

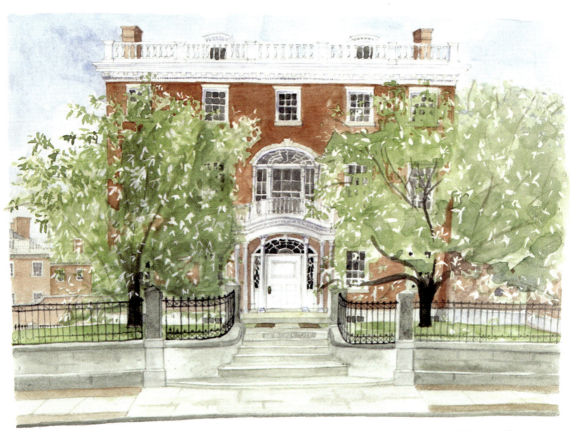

IVES HOUSE
BUILT 1803-1805
66 POWER STREET

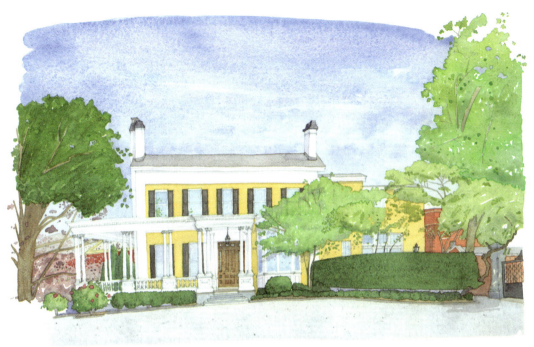

MOSES BROWN IVES HOUSE
BUILT 1835, 1867, AND 1898
10 BROWN STREET

STAR MAGNOLIA
MAGNOLIA STELLATA

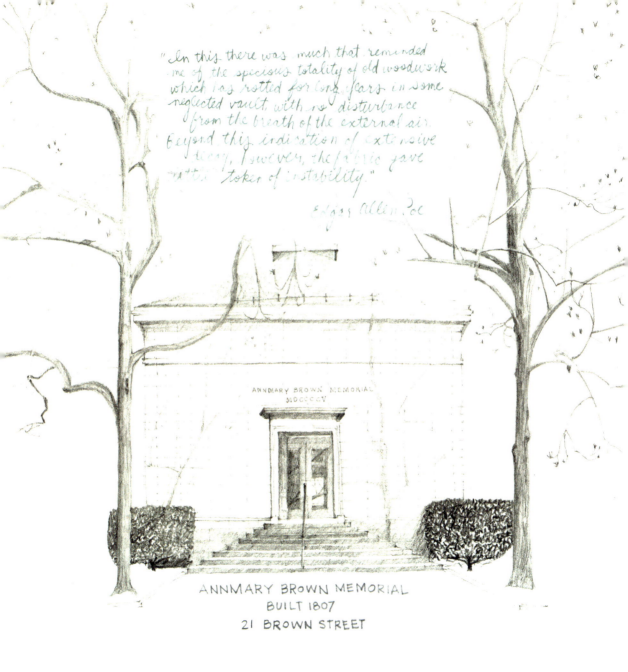

Crypt Rose

Like some Rare Flower entombed in Night
Its Beauty Shedding Everlasting Light

I believe in Unconditional Honesty. The Power of Practice of Truth. The influence of Noble aspirations and Love of the Beautiful.

Brown University

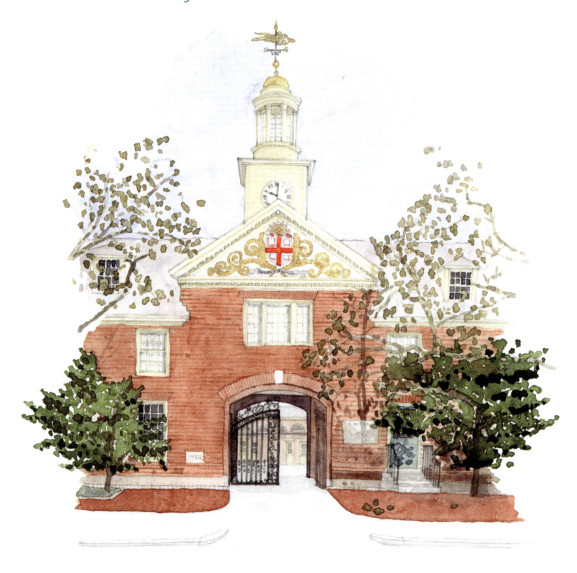

WILLIAM CLARK SAYLES
1855 – 1876
PAINTING BY GEORGE ALEXANDER HEALY

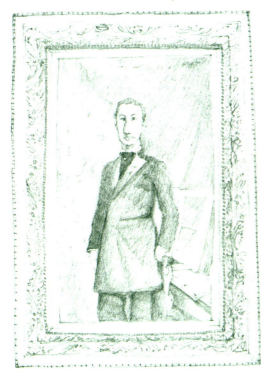

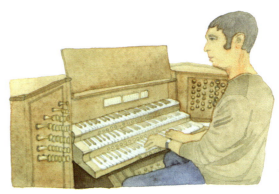

My friend Mark Steinbach, who plays the organ at Sayles Hall. The organ was built by the Hutchings-Votey Organ Company of Boston and has more than three thousand pipes.

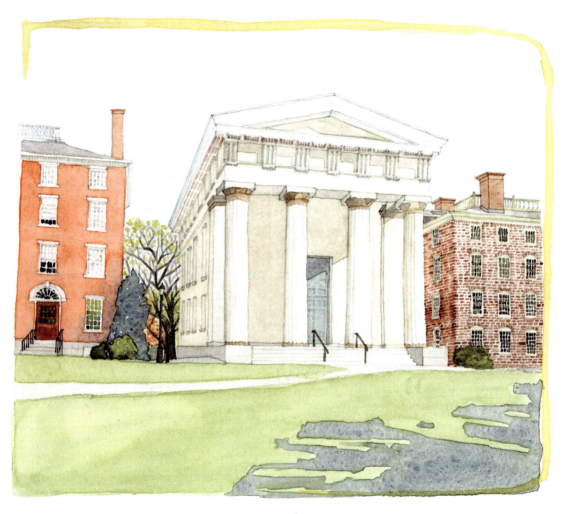

MANNING HALL
BUILT 1875
THE QUIET GREEN

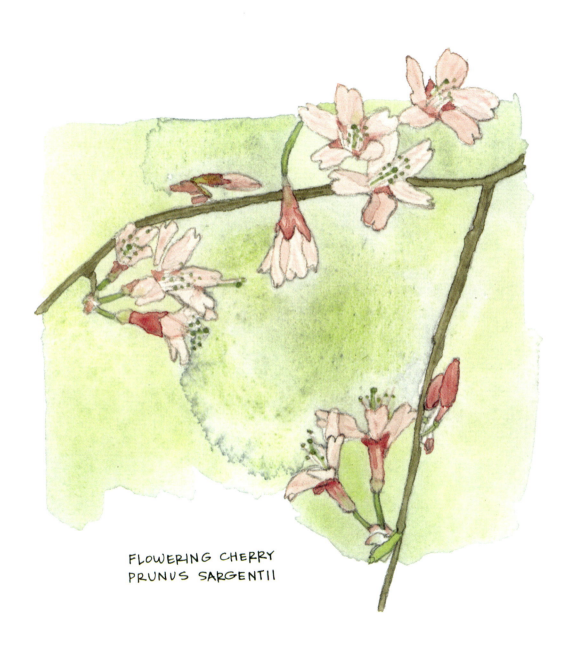

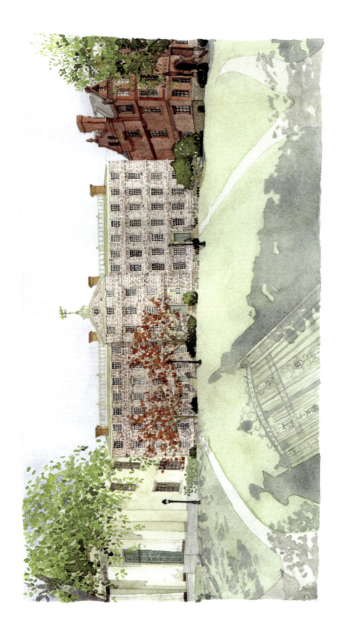

UNIVERSITY HALL
BUILT 1770
THE QUIET GREEN

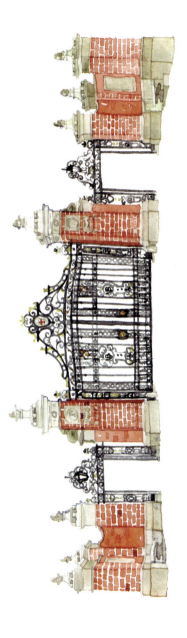

VAN WICKLE GATES
BUILT 1901
PROSPECT STREET

Van Wickle Gates are open only twice a year. Inward toward the campus on the day of Opening Convocation and outward on Commencement Day.

CARRIE TOWER
BUILT 1904
THE QUIET GREEN

Inscription: "Love is Strong as Death."

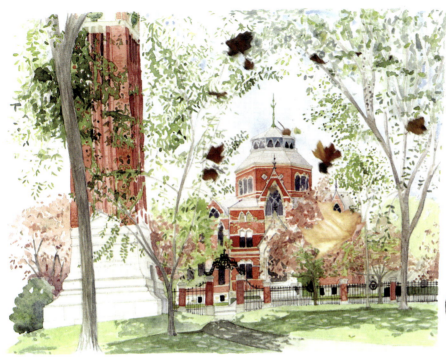

ROBINSON HALL AND
THE CARRIE TOWER
BUILT 1878 & 1904 RESPECTIVELY
64 WATERMAN STREET

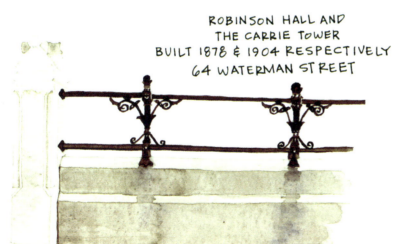

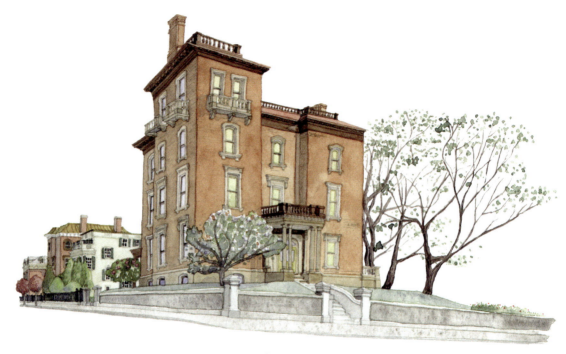

CORLISS-BRACKETT HOUSE
BUILT 1875
45 PROSPECT STREET

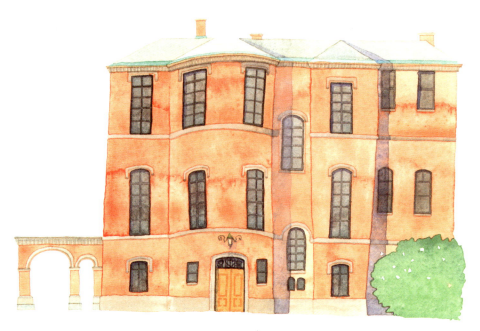

WOODS GERRY HOUSE & GATE
BUILT 1863
62 PROSPECT STREET

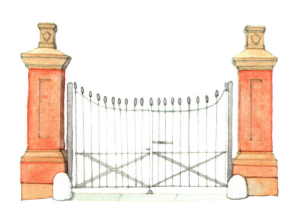

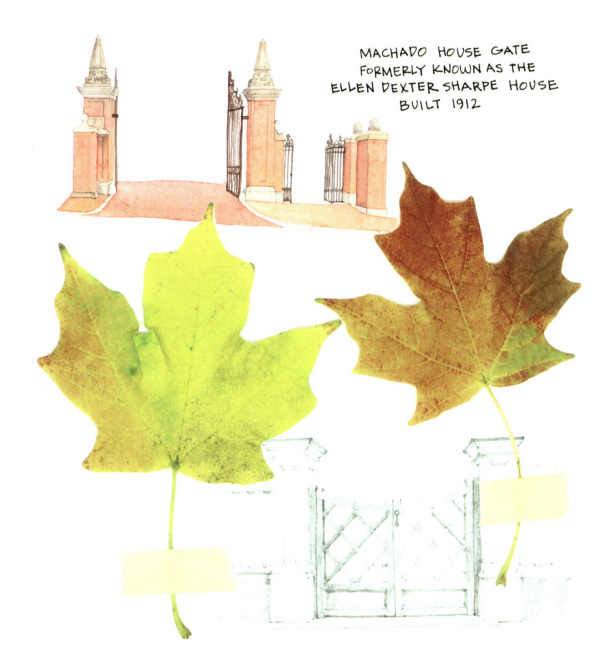

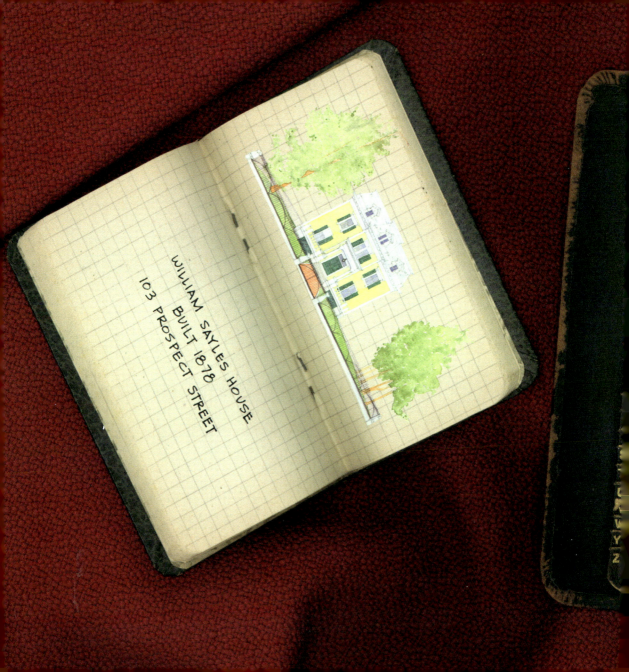

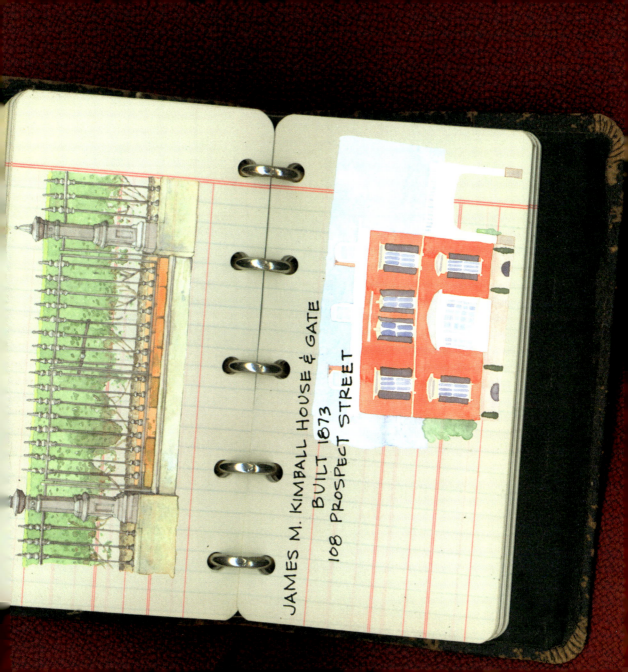

JAMES M. KIMBALL HOUSE & GATE
BUILT 1873
108 PROSPECT STREET

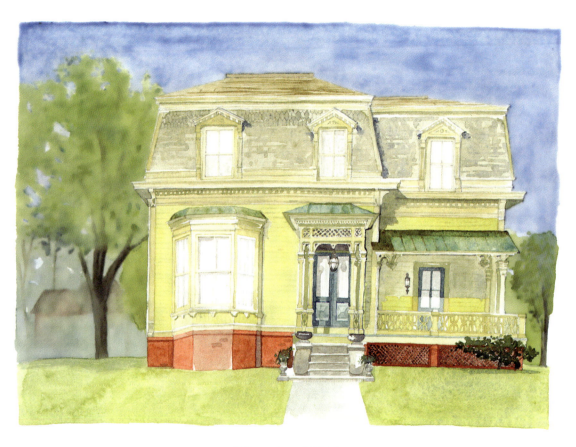

JAMES BURDICK HOUSE
BUILT 1876
141 PROSPECT STREET

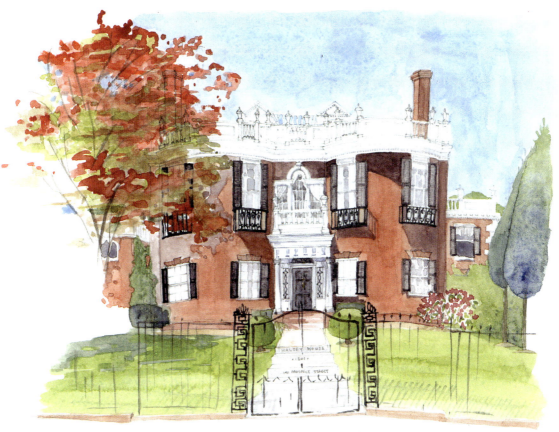

HALSEY HOUSE
BUILT 1801
140 PROSPECT STREET

EMMA D. SMITH & EMMA J. SMITH HOUSE
BUILT 1854
98 CONGDON STREET

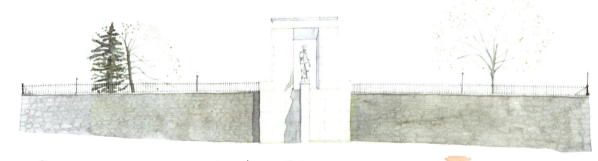

ROGER WILLIAMS SCULPTURE & TOMB
AT PROSPECT PARK
CONGDON STREET
(PRATT STREET WALL ELEVATION SHOWN)

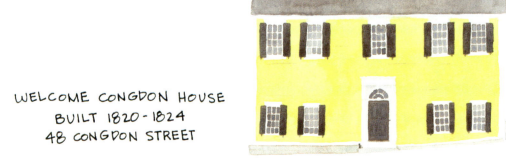

WELCOME CONGDON HOUSE
BUILT 1820-1824
48 CONGDON STREET

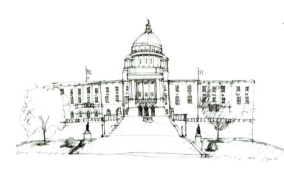

RHODE ISLAND STATE HOUSE
BUILT 1895-1904
SMITH STREET

The Rhode Island State House was designed by the architecture firm McKim, Mead, and White at a time when Rhode Island was one of the wealthiest states per capita. It cost three million dollars to build, which is about one billion in today's dollars. The state house is made of Georgia white marble and was one of the first public buildings to use electricity and to use skylights.

Following World War II, each state was presented with a reproduction of the Liberty Bell as a token of appreciation for each state's contribution to the war effort. The original Liberty Bell is located in Independence Hall in Philadelphia and was rung to announce the adoption of the Declaration of Independence. Do you know why the Liberty Bell has a crack in it? It developed a crack in 1835 when it was rung in mourning for Chief Justice John Marshall.

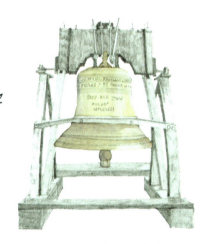

REPRODUCTION OF THE
PHILADELPHIA LIBERTY BELL

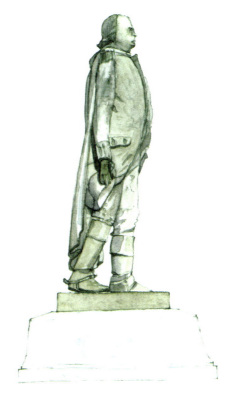

NATHANAEL GREENE SCULPTURE
ERECTED 1931

Nathanael Greene commanded the first Brigade of Rhode Islanders to join the Continental Army in the siege of Boston in June 1775.

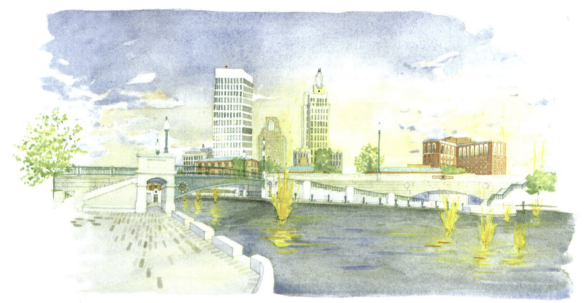

WATERPLACE PARK
BUILT 1994

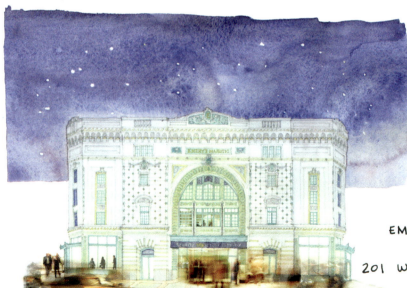

TRINITY REP
EMERY'S MAJESTIC
BUILT 1917
201 WASHINGTON STREET

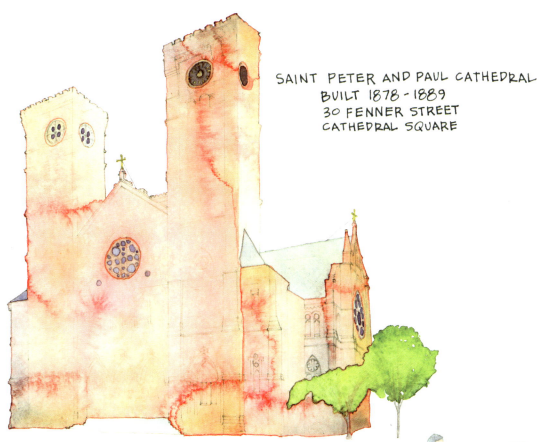

SAINT PETER AND PAUL CATHEDRAL
BUILT 1878 - 1889
30 FENNER STREET
CATHEDRAL SQUARE

The Cathedral of Saint Peter and Paul was designed by Patrick C. Keely and is made of brown sandstone. The cathedral contains the largest mechanical action organ in North America and is the mother church of the Roman Catholic Diocese of Providence.

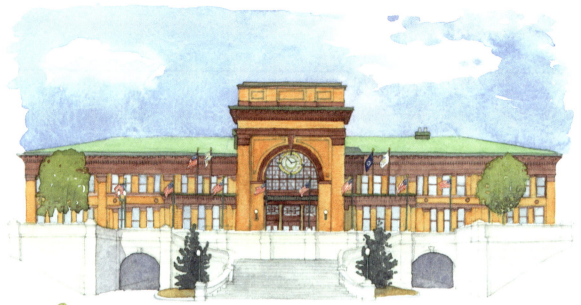

UNION STATION
BUILT 1898

Across the street from Union Station lies Burnside Park where the Bajnotti Memorial Fountain is located. Paul Bajnotti donated the fountain in memory of his wife Carrie Brown, daughter of the prominent Providence resident Nicholas Brown. The fountain was designed by Enid Yandell of New York City and cast by the Providence-based Gorham Company.

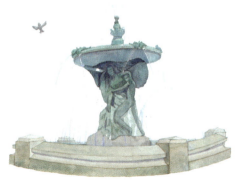

BAJNOTTI FOUNTAIN
1899

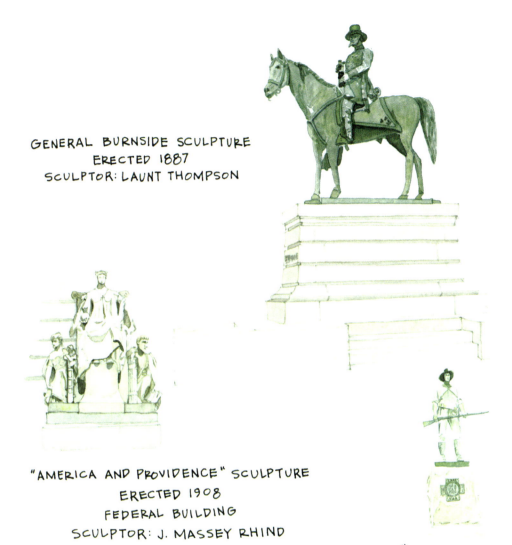

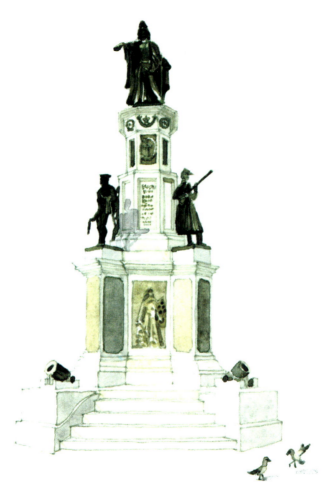

"SOLDIERS AND SAILORS" MONUMENT
BUILT 1866-1871
SCULPTOR: RANDOLPH ROGERS
ARCHITECT: ALFRED STONE

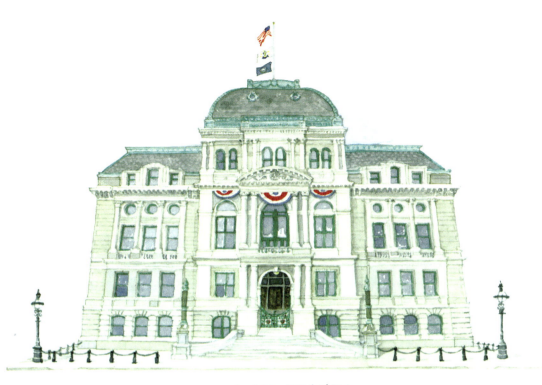

PROVIDENCE CITY HALL
BUILT 1878
25 DORRANCE STREET

Providence City Hall was designed by Samuel J.F. Thayer and is in the French Second Empire Style. The exterior is clad in Westerly and New Hampshire granite. In the pediment, there is a bust representing Roger Williams, founder of Providence.

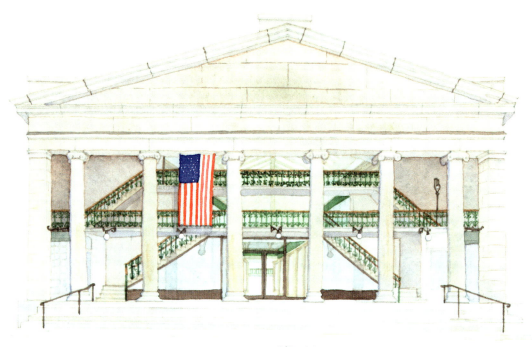

THE ARCADE
BUILT 1828
130 WESTMINSTER STREET (SHOWN)
AND 65 WEYBOSSET STREET

The Arcade is the oldest shopping mall in the United States still standing and the first commercial development on the west side of the Providence River. It was designed by Russell Warren and James Bucklin in the style of a Greek temple. Due to a disagreement between the two groups that invested in the building, the Westminster and Weybosset Street elevations do not match. The exterior is built entirely of granite and has twelve columns - each thirteen tons - the largest monolithic columns in the country at the time. The stone columns were brought by oxen from Johnston, Rhode Island.

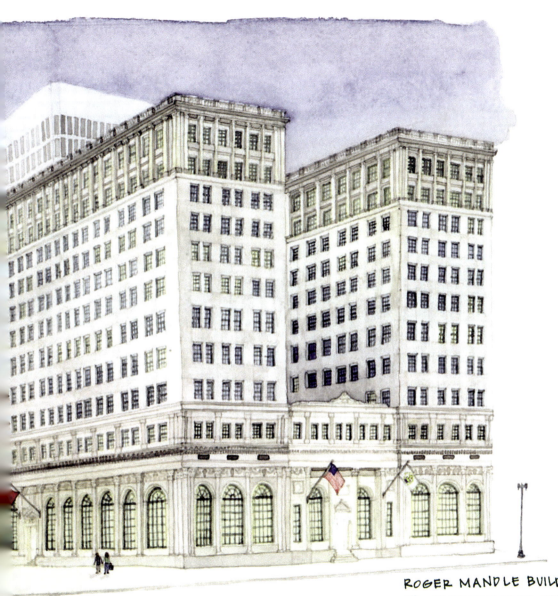

ROGER MANDLE BUILDING
15 WESTMINSTER STREET
BUILT 1917

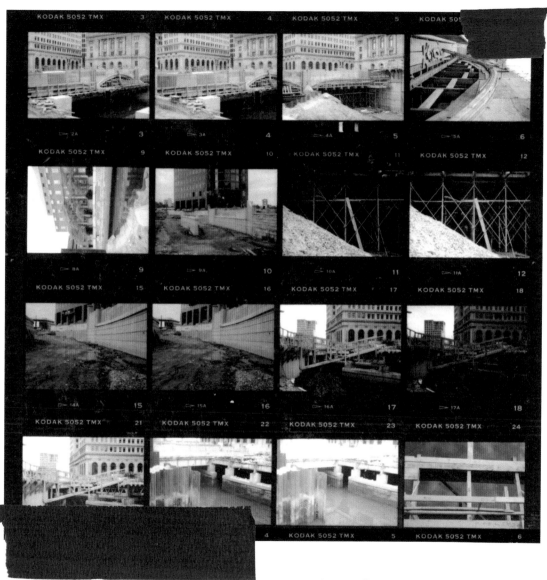

Pictures taken of the rerouting of the Providence River (1991).

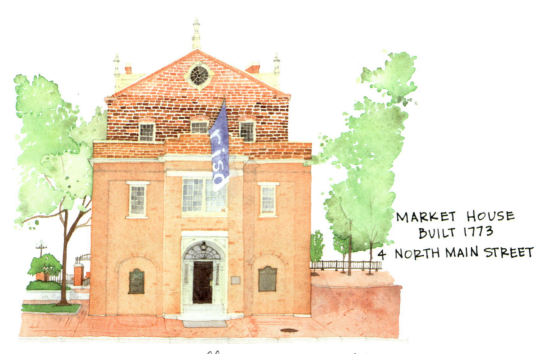

MARKET HOUSE
BUILT 1773
4 NORTH MAIN STREET

Market House was originally a two-story building designed by Joseph Brown and was located at Market Square, an outdoor market for food and, at times, the selling of slaves. Market House is located at the northernmost point where boats could navigate the Providence River at low tide. The first floor was used as an open market and the second floor for offices. Market Square is the site of the burning of tea to protest the British Tea Tax on the colonies. During the American Revolution, Market House was used for army barracks. In 1797, the third floor was added. Market House is the second oldest public building in Providence and is currently used by the Rhode Island School of Design.

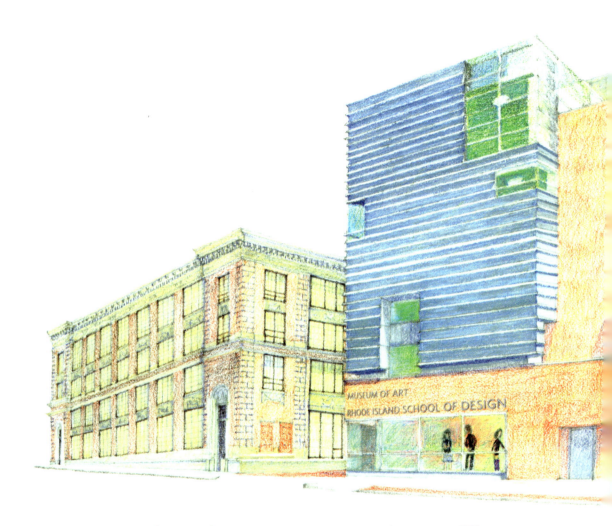

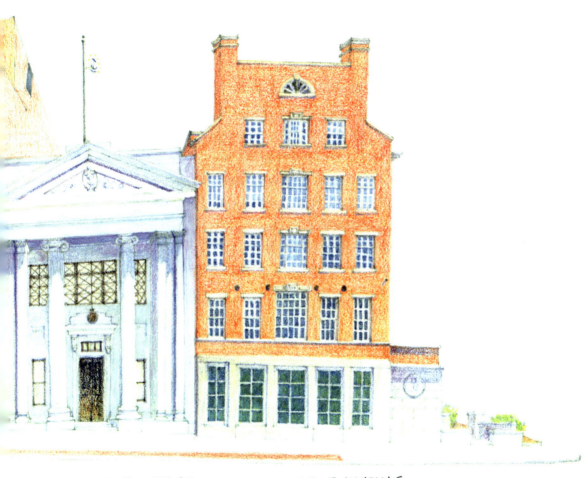

THE BANK BUILDING
27 MARKET SQUARE
BUILT 1913

COLLEGE BUILDING
BUILT 1823-24
2 COLLEGE STREET

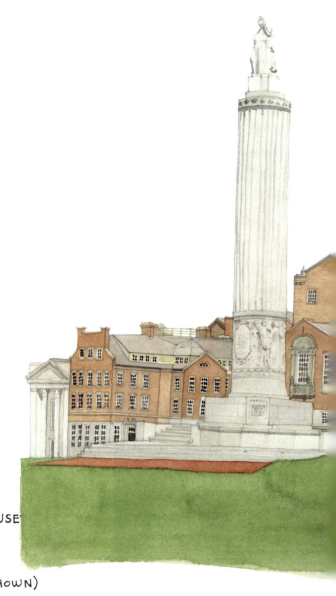

PROVIDENCE COUNTY COURTHOUSE
LICHT JUDICIAL COMPLEX
BUILT 1924-1933
250 BENEFIT STREET
(SOUTH MAIN STREET ELEVATION SHOWN)

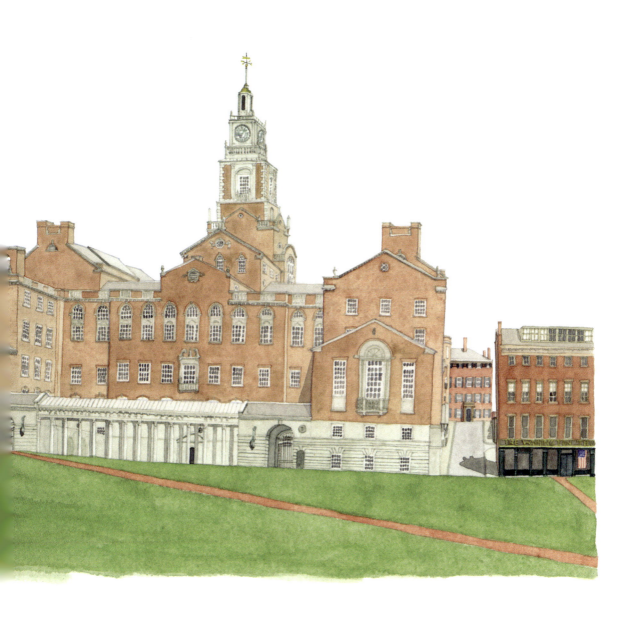

The Providence Institution for Savings built the "Old Stone Bank" in 1898, and the bank was commonly referred to by that name. In 1967 the bank officially changed its name to The Old Stone Bank. The building was designed by the Providence architecture firm Stone, Carpenter, and Willson.

To the south of the Old Stone Bank is the Benoni Cooke House, designed by the Providence architect John Holden Greene in the Federal style. A similar house existed across a courtyard at the site of the Old Stone Bank but was demolished to make way for the bank. The adjacent house was occupied by Cooke's brother-in-law.

To the north of the Old Stone Bank is the Joseph Brown House. Joseph Brown was an architect and brother of prominent Providence residents John, Nicholas, and Moses Brown. Interestingly, a French officer stayed at the house and after a meal rode his horse up the steep steps and through the great hall, but the horse refused to walk down the steps so the horse had to exit through the large rear door of the house.

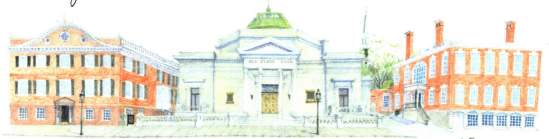

JOSEPH BROWN HOUSE
BUILT 1774
50 SOUTH MAIN STREET

THE OLD STONE BANK
BUILT 1898
86 SOUTH MAIN STREET

BENONI COOKE HOUSE
BUILT 1828
110 SOUTH MAIN STREET

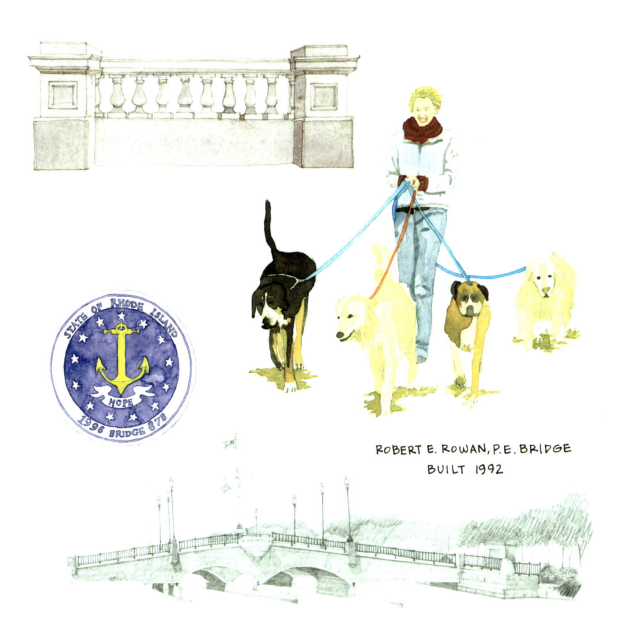

200 SOUTH MAIN STREET

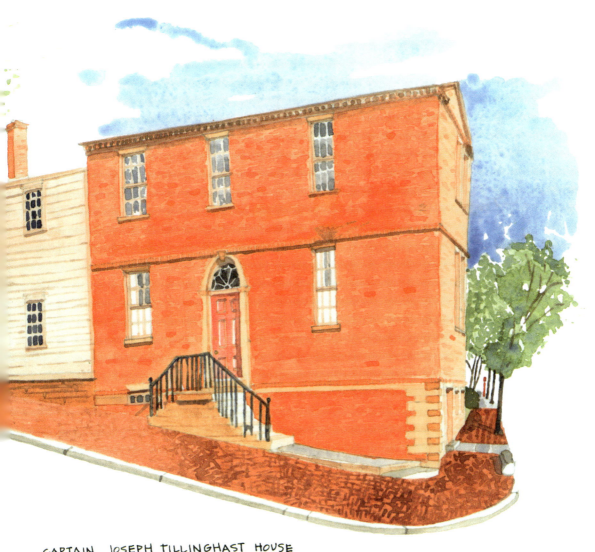

CAPTAIN JOSEPH TILLINGHAST HOUSE
BUILT 1796
12 JAMES STREET

Ever wonder why there is a front door on the second floor of this building? The house was raised one story to make space for a floor of stores.

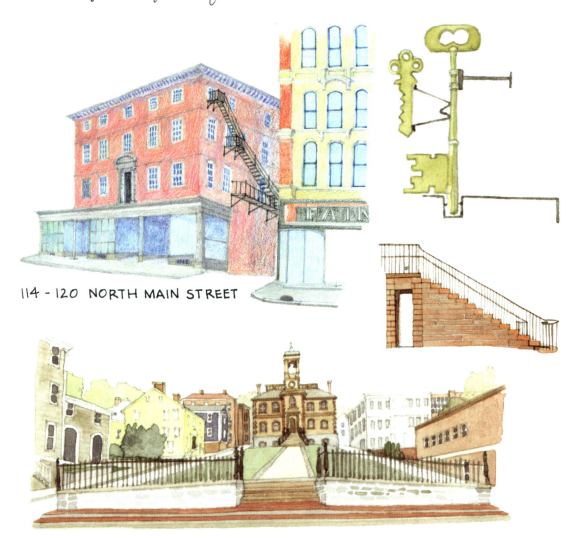

114 - 120 NORTH MAIN STREET

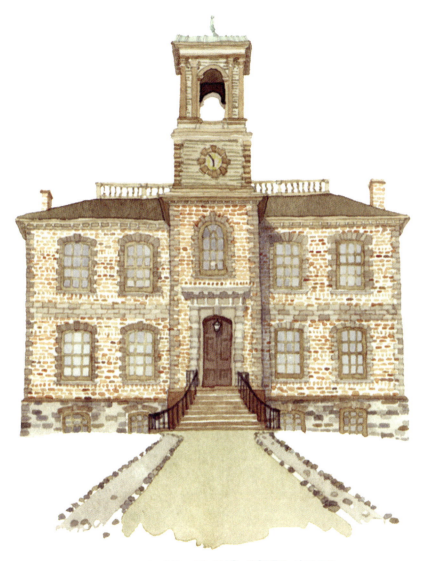

OLD RHODE ISLAND STATE HOUSE
BUILT 1762
150 BENEFIT STREET (NORTH MAIN ST. ELEVATION SHOWN)

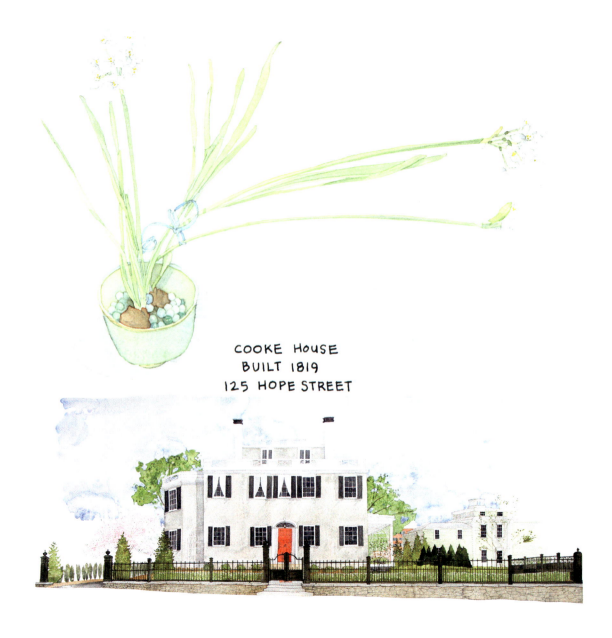

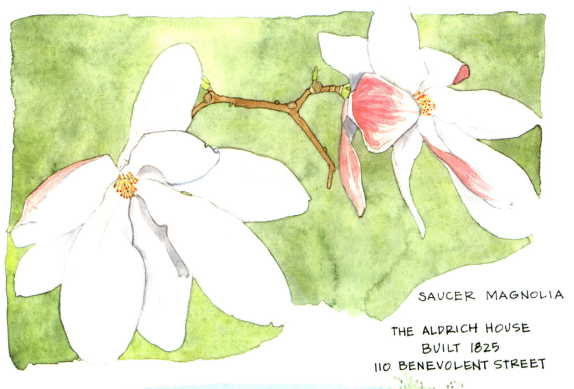

SAUCER MAGNOLIA

THE ALDRICH HOUSE
BUILT 1825
110 BENEVOLENT STREET

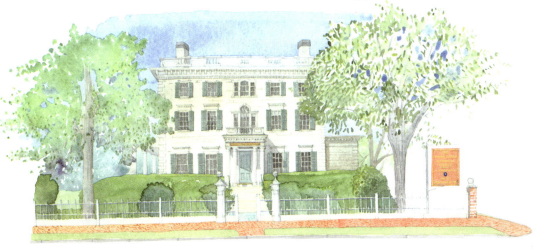

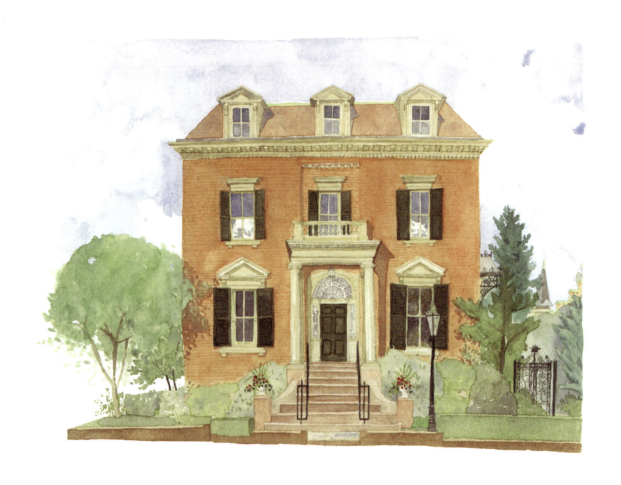

BENJAMIN ADAMS HOUSE
BUILT 1871-1872
26 COOKE STREET

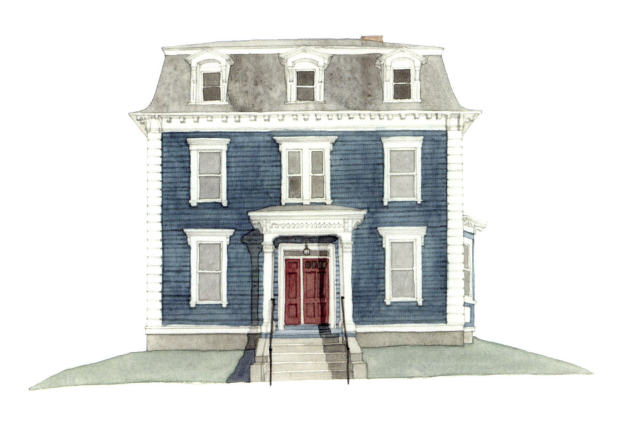

ALMIRA T. DEXTER HOUSE
BUILT 1867
21 EAST GEORGE STREET

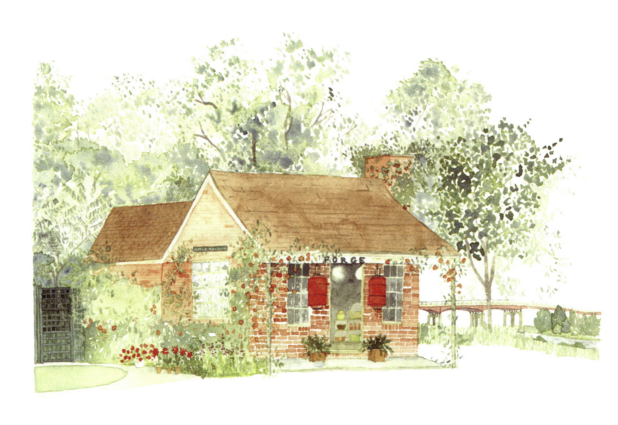

THE OLD FORGE
6 RICHMOND SQUARE
BUILT 1884

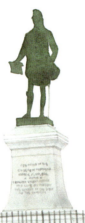

EBENEZER KNIGHT DEXTER SCULPTURE
BUILT 1893

RHODE ISLAND STATE ARMORY
BUILT 1907
125 DEXTER STREET

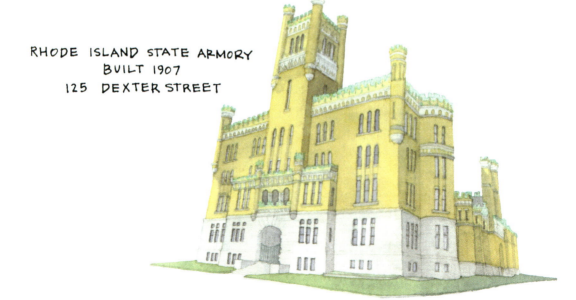

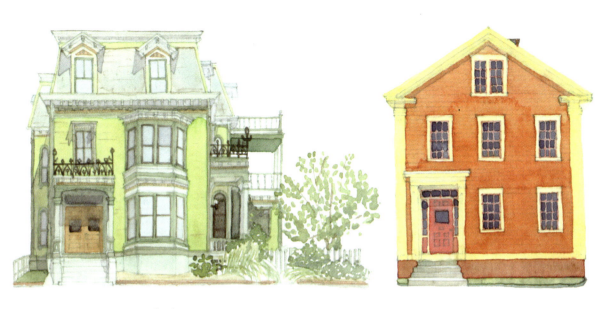

JOHN I. SMITH HOUSE
BUILT 1883
DEXTER STREET

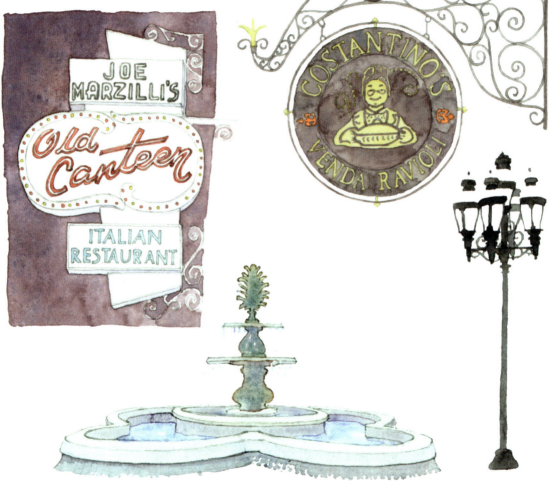

TONY'S COLONIAL FOOD STORE
SINCE 1952
311 ATWELLS AVENUE

SCIALO BROTHERS BAKERY
SINCE 1916
257 ATWELLS AVENUE

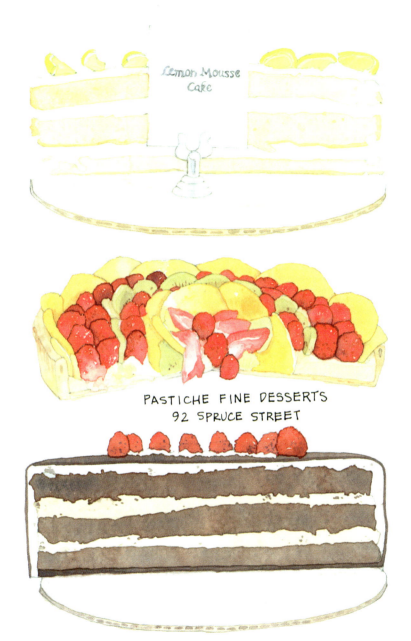

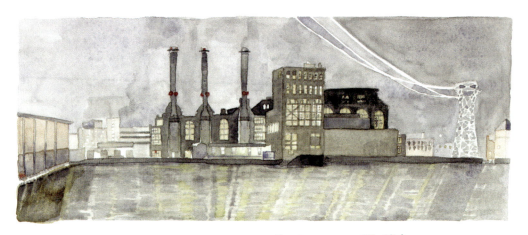

NARRAGANSETT ELECTRIC COMPANY
MANCHESTER ST. GENERATING STATION
BUILT 1904
40 POINT STREET

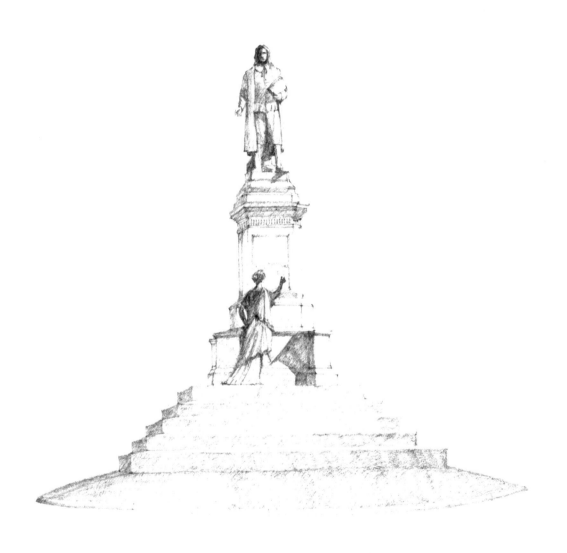

ROGER WILLIAMS SCULPTURE
ROGER WILLIAMS PARK

OUTSIDE PROVIDENCE

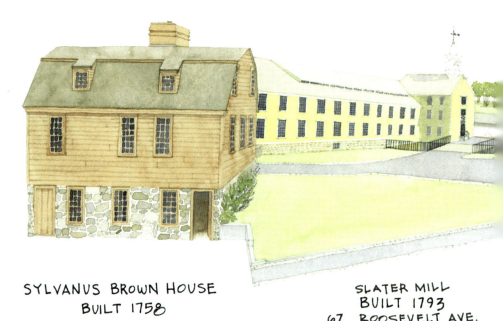

SYLVANUS BROWN HOUSE
BUILT 1758

SLATER MILL
BUILT 1793
67 ROOSEVELT AVE.

Samuel Slater came to America after learning about the industrial production of textiles in England. With money from Providence resident, Moses Brown, Slater built the first textile mill in the United States, thus launching the Industrial Revolution in America. The original mill was enlarged to its current appearance.

Pawtucket

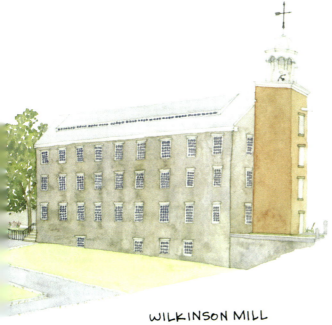

WILKINSON MILL
BUILT 1810

Seventeen years later, Wilkinson Mill was built, adopting changes to accommodate improvements in mill construction. The brick tower was added in 1840. Both mills were built long and narrow to maximize the use of natural light and to accommodate the water wheel and the gears, shafts, and belts to run the machinery in the mills.

The Sylvanus Brown House was relocated to the current location in 1973.

180 SHERMANTOWN ROAD

NASTURTIUM
TROPAEOLUM
literally "nose-twister"

Saunderstown

LILAC

Narragansett

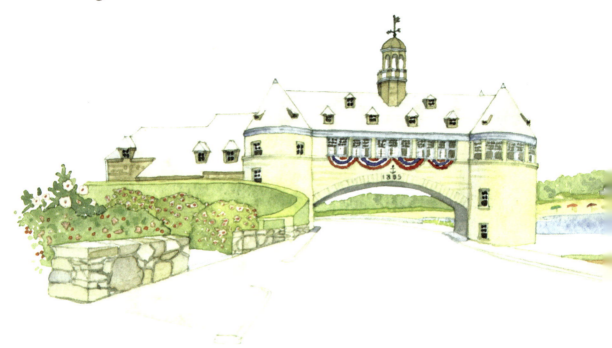

**NARRAGANSETT TOWERS
BUILT 1885**

The Narragansett Towers are a last vestige of the Narragansett Casino. The Towers were the entrance to the Casino with a covered breezeway above. Both the Towers and the Coast Guard House (shown in its original appearance) were designed by the architecture firm McKim, Mead, and White.

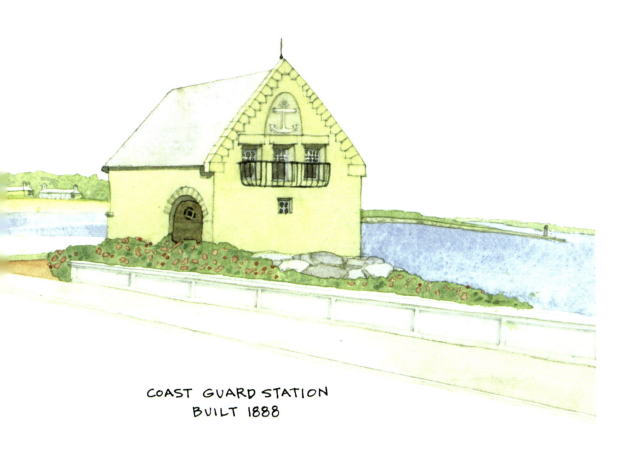

COAST GUARD STATION
BUILT 1888

During the 19th century the term "casino" referred to buildings where social activities took place. The Narragansett Casino was never a location of public gambling.

BEACH AT NEWTON AVENUE

Kingston

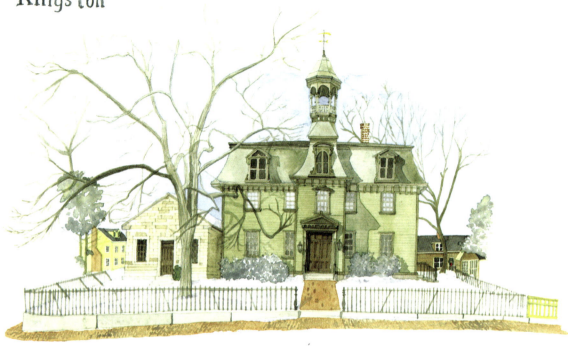

KINGS COUNTY COURTHOUSE
BUILT 1775
AND
COUNTY RECORDS OFFICE
BUILT 1857

LIQUID AMBER

Osquepaug

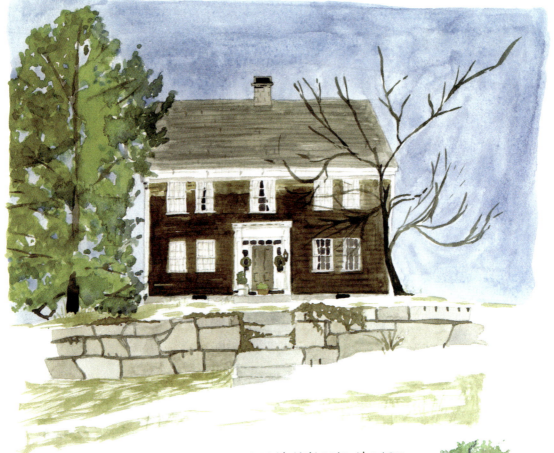

DR. NATHAN KNIGHT HOUSE
BUILT 1785

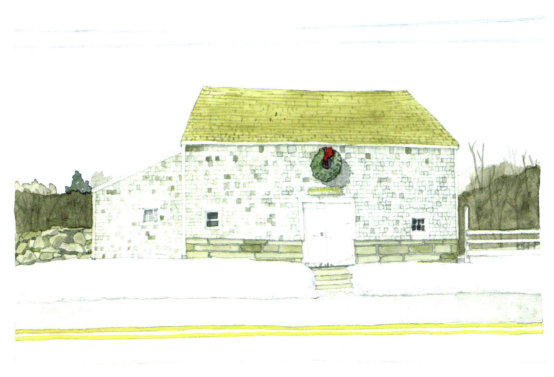

LINDENBROOK FARM

E & E STABLES
CAROLINA

Bristol

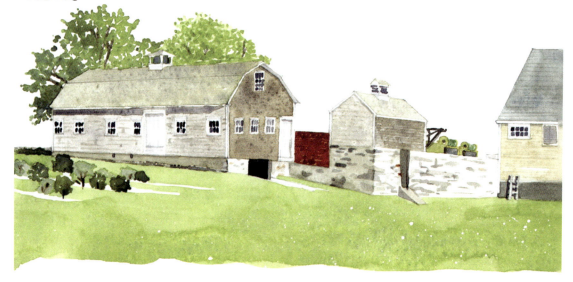

DEWOLF FARM

QUEEN ANNE'S LACE
DAUCUS CAROTA

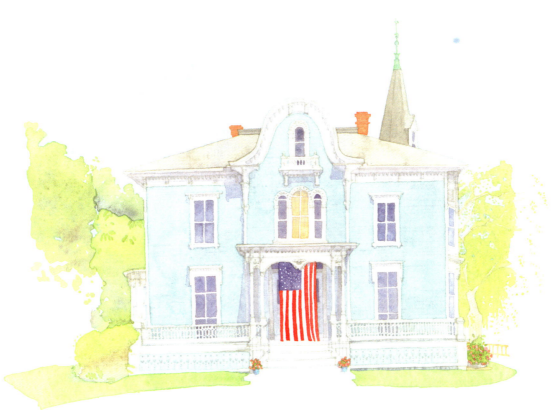

SETH PAULL HOUSE
BUILT 1881
900 HOPE STREET

Tiverton

SQUID

FLOUNDER

Classic Rhode Island Recipe

Crab + Corn Chowder

- 2 sticks butter
- 4 leeks, chopped
- 1 large Spanish onion, diced
- 4 celery stalks, chopped
- 2 cups flour
- 1 46-ounce can clam juice
- 6 ears uncooked corn (off cob)
- 1 lb. lump crab, fresh or canned
- 4 red potatoes, cubed and cooked
- 2 cups heavy cream, heated
- 1 teaspoon thyme
- 1 bay leaf
- 2 tablespoons fresh cracked pepper
- 1 teaspoon dill

Add butter, leeks, onions, and celery, then sauté until translucent. Slowly add flour and cook for five minutes over medium-low heat. Gradually add clam juice and corn, bring to a simmer. Add remaining ingredients and simmer five to ten minutes. Serve with dill garnish.

Middletown

ST. GEORGE'S SCHOOL CHAPEL
BUILT 1928
372 PURGATORY ROAD

The chapel was designed by Ralph Adams Cram.

NEWPORT

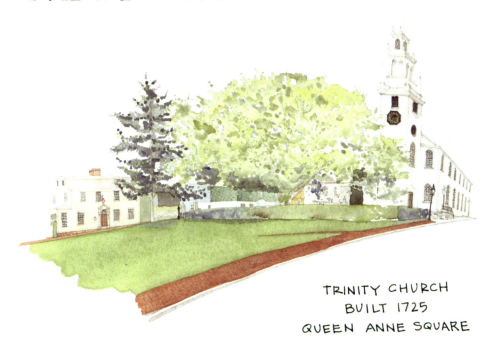

TRINITY CHURCH
BUILT 1725
QUEEN ANNE SQUARE

The Church of England was introduced to Newport in 1699 at a time when the population was made up of ex-Puritans, Baptists, and Quakers. The present church, designed by Richard Munday in 1725, replaced a smaller structure on the same site.

The Brick Market was designed in the neo-classical style by Peter Harrison who also designed Redwood Library and Touro Synagogue. Originally the building was used as an open-air farm produce market. By the 1790's the building was used as a hardware store on the first floor and a theatre on the second floor. By 1842 the building was used as Newport Town Hall.

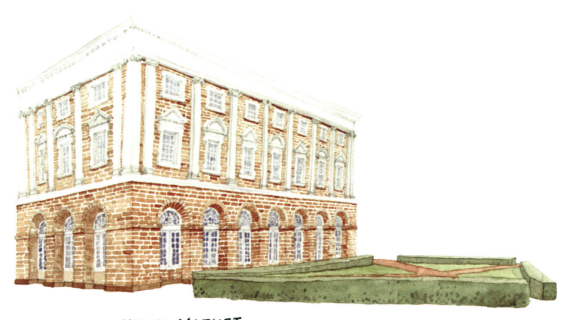

BRICK MARKET
BUILT 1762
127 THAMES STREET

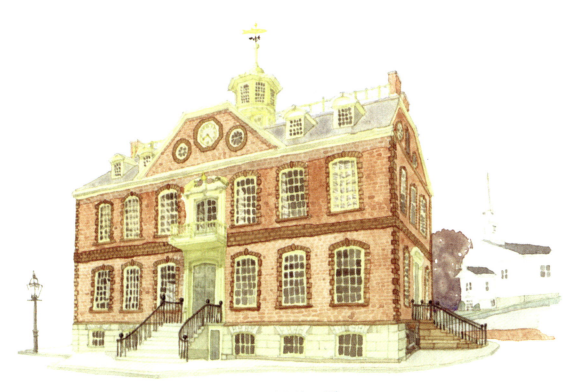

COLONY HOUSE
BUILT 1736-1739
WASHINGTON SQUARE

Colony House was one of the original five state houses in Rhode Island. Builder/architect Richard Munday designed the building in the English Georgian style and was an initial effort to bring orderly town planning to Newport. Between 1901 and 1926, Colony House functioned as the Newport County Courthouse.

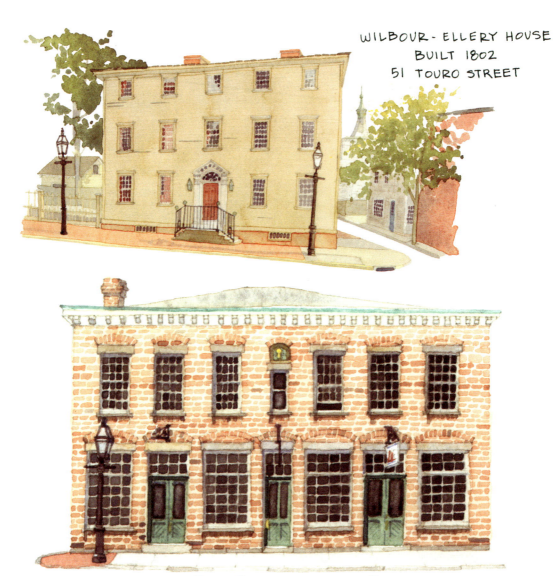

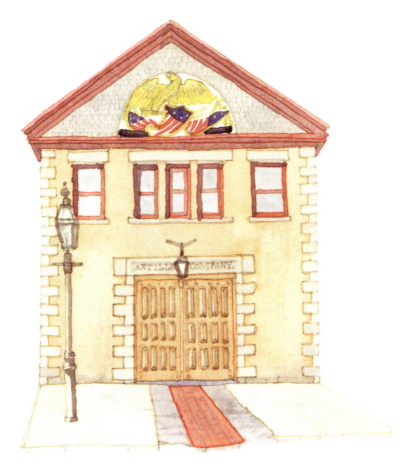

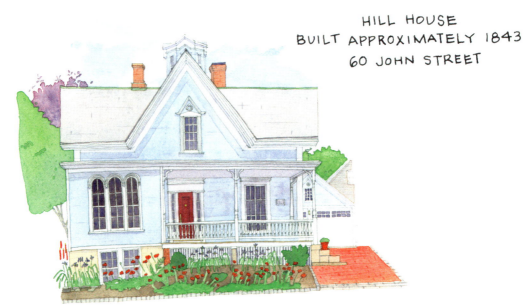

HILL HOUSE
BUILT APPROXIMATELY 1843
60 JOHN STREET

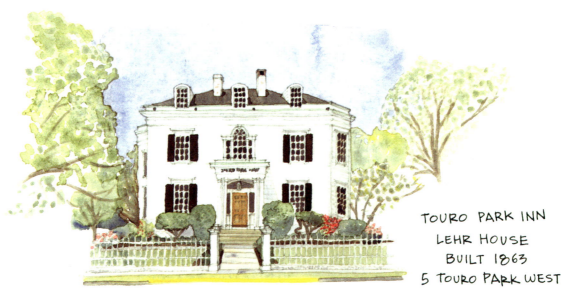

TOURO PARK INN
LEHR HOUSE
BUILT 1863
5 TOURO PARK WEST

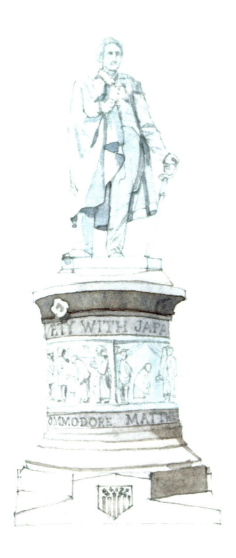

COMMODORE MATTHEW C. PERRY SCULPTURE
ERECTED 1868

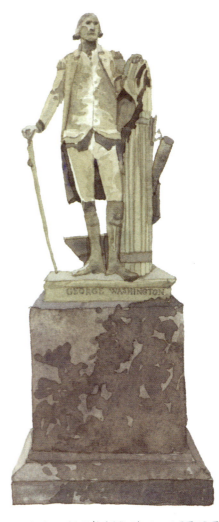

GEORGE WASHINGTON SCULPTURE
AT THE REDWOOD LIBRARY
ORIGINAL MADE IN 1788
REPRODUCED IN 1932

Text of George Washington's letter to Touro Synagogue (1790)

"... For happily the Government of the United States, which gives to bigotry no sanction, to persecution no assistance, requires only that they who live under its protection, should demean themselves as good citizens, in giving it on all occasions their effectual support."

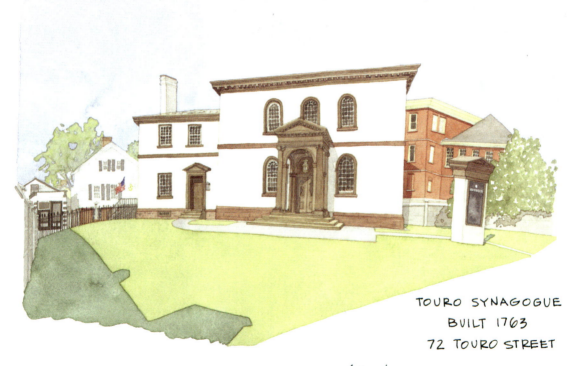

TOURO SYNAGOGUE
BUILT 1763
72 TOURO STREET

Touro Synagogue was designed by the pre-eminent colonial architect Peter Harrison.

INTERNATIONAL TENNIS HALL OF FAME
AT THE
NEWPORT CASINO
BUILT 1881
186-202 BELLEVUE AVENUE

ISAAC BELL HOUSE
BUILT 1883
424 BELLEVUE AVENUE

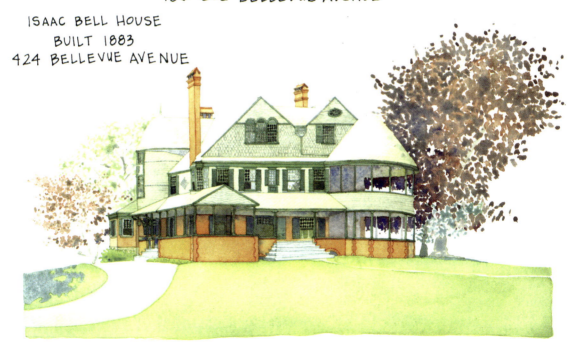

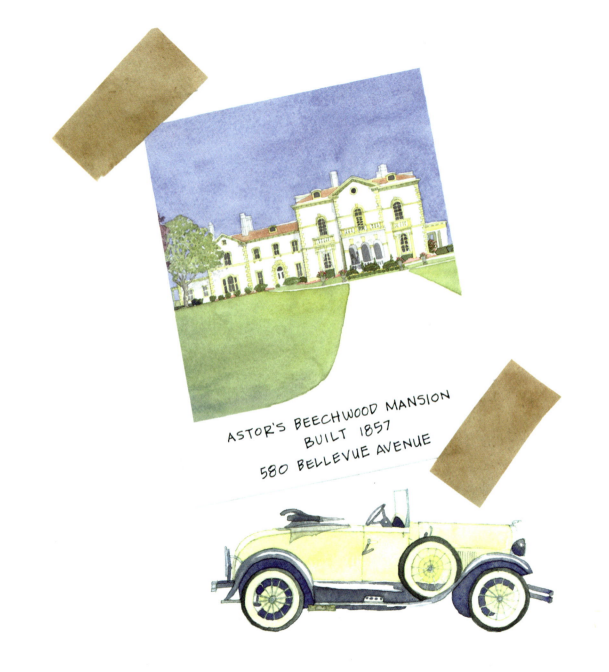

The Breakers was designed by Richard M. Hunt for the family of Cornelius Vanderbilt. The 70-room limestone summer home is in the Renaissance Revival Style and was inspired by 16th century palaces of Genoa and Turin, Italy. During the construction, entire rooms were mocked up in Europe and then the interiors were shipped to Newport for installation at The Breakers.

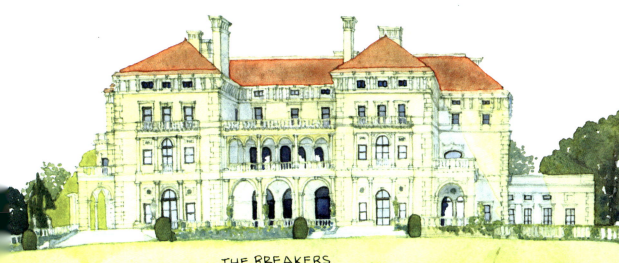

THE BREAKERS
BUILT 1893-1895
44 OCHRE POINT AVENUE
(CLIFF WALK VIEW SHOWN)

Dedicated to all those who keep Rhode Island beautiful.

About the author and Illustrator: Tom Gastel is a graduate of the Rhode Island School of Design and is an Architect and Architectural Illustrator. Please visit www.TomGastel.com.

Copywrite © 2008 and 2013. No portion of this book can be reproduced without the written permission of the author.

Printed in the United States.